Diary of a Poet

Diary of a Poet

VOLUME 1

Jessica McDaniel

authorHOUSE®

AuthorHouse™ LLC
1663 Liberty Drive
Bloomington, IN 47403
www.authorhouse.com
Phone: 1-800-839-8640

Published by AuthorHouse 06/10/2014

ISBN: 978-1-4918-6937-6 (sc)
ISBN: 978-1-4918-6938-3 (e)

Library of Congress Control Number: 2014903758

Any people depicted in stock imagery provided by Thinkstock are models, and such images are being used for illustrative purposes only. Certain stock imagery © Thinkstock.

This book is printed on acid-free paper.

Because of the dynamic nature of the Internet, any web addresses or links contained in this book may have changed since publication and may no longer be valid. The views expressed in this work are solely those of the author and do not necessarily reflect the views of the publisher, and the publisher hereby disclaims any responsibility for them.

Scripture verses marked KJV are from the King James Version of the Bible unless otherwise noted.

Table of Contents

Acknowledgments

Thanks be to God for giving me the gift of poetry and words to speak! I want to thank all the poetry lovers and buyers of this book. I want to thank everyone who helped or encouraged me in any way related to this book. It's appreciated and never taken for granted. I pray that this book touches everyone who reads it

Love,

Jessica

Eviction

Dear Satan, Liar, Accuser, and Thief,
Thought I'd serve you a final notice.
See, I know your attacks and motives.
You're trying to steal, kill, and destroy everything that God has for me,
But you can't have my life because of who owns me!
You've tried throwing your fiery darts as your blows tried to hit my mind, soul, and spirit
And I've take it too lightly, but finally I've put on the full armor; this is it!
I've been too polite in my good-byes as you've invaded my life.
You've tried sifting me as wheat, and I was blinded
Because my eyes stayed focused on your distractions.
I was too lazy and unfocused to see your tactics.
You've tried to take me down too long without me even giving you a fight.
You've caused so much heartache, pain, and strain in my life
That I could've avoided, and you've enjoyed it.
And as I was stuck in iniquity, you rejoiced every time,
Wanting me to pack my bags filled with the deadly sins I carried,
Waiting to give me a one-way ticket and seat in hell with you.
But you have no power or authority; I don't belong to you!
See the kingdom suffereth violence, and the violent take it by force.
So evacuate as I take back everything you've tried to steal,
Every gift, every dream you've wanted unfulfilled and tried to kill
Every ounce of peace and part of my destiny you've tried to steal:
I take it back! I take it all back! I take it all back!
And as I give you this final eviction, never return!
Your imps and your demons must flee! Get thee behind me!
Because who the *son* sets free is free indeed!

It's Just Too Late

Fornication, unforgivness, low self-esteem, and doubt:
Just a few of my sins I should've lived without,
Because no matter how small they seemed,
I knew the wages were death, but it didn't bother me.
No, I wasn't married, but fornication, it was just my thing.
It didn't matter that I was defiling my body.
It was just meaningless, pointless sex.
AIDS, HIV, STDs, unwanted pregnancy, child support,
Child abortion, meds, "when it comes to one year old you are not the
father"
Were some of the small possibilities that would bring nothing but
pain and misery.
"Hated him," "couldn't stand her," forgiveness just wasn't in me,
Didn't care how you forgave me according to Mathew 6:14;
So what? Yes I was bought with a price, and you gave your life
That I might have a chance to live mine right
What did that mean to me? Not a thing!
It was just so many memories, recording over and over,
Stuck on rewind, steadily playing on that DVD in my mind.
Yeah, those covered wounds didn't get healed; they
Just left me weak, so I stayed still.
Bound, bound in sin, walking around with my head held down,
Continuing to go in circles, around and around,
Filled with low self-esteem, didn't matter that you gave me victory
over everything,
Didn't matter how I was fearfully and wonderfully made:

I wanted to look like that girl on TV, on stage, or in the magazines.
And I never loved me, just the things of the world,
Although it contradicted your word and ways according to what 1
John 2:15 says.
Didn't matter how you forgave me over and over. I
Didn't repent, even though your kingdom was at hand and I had
chance after chance. I
Had so many problems I just couldn't understand,
Despite the fact that your word is living and powerful and more than
able to deliver me.
Never prayed, not even to say thanks, only to tell you what I wanted
and needed,
Even though daily I should've stayed on my knees.
Never talked to you; it wasn't that I didn't want to.
It was just that I didn't believe you or that you could do what you said
you would do,
Even though you're not a man that would lie, but the Truth, Way, and
Light.
Not one day did I go to church after the age of eight!
You going to church? Who me? Not today!
Despite the fact that I didn't care that 99 in a half just wouldn't do,
And never gave honor where it was due, you still called me your child.
But I still denied you time after time,
Putting you right back on that cross they nailed you to.
Now I realize the error of my ways, but now it's also judgment day,
And all I could say was, "I'm sorry. It's just too late."
Turned away, unable to see your face, and now I'm dreading this
other place.

9-11 Emergency

Walking in rebellion, confusion, and distress,
The world shows me one thing, but your word tells me another,
So how do I believe?
You say you're a healer, a redeemer, and a way maker of everything.
But I'm still trapped and bound, still sick, miserable, depressed, and
even more stressed.
But you promised to give me rest.
I prayed and prayed, yet nothing changed! Just more feelings of pain.
Are you there? Do you even care? You say your love remains the same.
Feeling at the end of my rope, I'm ready to throw in the towel; this is
the final straw.
Everything in me wants to give up and give in.
So, Lord, this is a 9-11 emergency.
Are you really here with me? Because I feel so empty.
I'm in critical condition, flat-lining; please resuscitate me!
Hmm, it's as if I had an epiphany; the smoke is cleared.
My eyes have opened. Maybe, could it possibly be me?
Clear! I'm still in that ungodly relationship you told me to leave
Years ago; I still haven't done it.
Clear! That fasting and prayer you recommended? I still didn't do it.
Clear! Maybe it's that lust in my heart I still haven't prayed away.
Clear! Maybe it's the fact that when I keep compromising and settling,
I'm letting the enemy use me every time! Clear!
Maybe it's the fact that I ignore your signs.
Clear! The fact that I still haven't given you all of me,
And what you've called me to do I still haven't done.

Clear! The fact I haven't truly repented,

The fact I go two steps ahead of you instead of moving when you instruct me to.

Oh yeah, that's right: obedience is better than sacrifice.

You reap what you sow, but what exactly have I sown?

Clear! Maybe it's the alcohol and drugs I continue to use instead of coming to you.

Maybe I was so conformed to the world and wasn't about you're business

I failed the test, its true: you don't bless mess.

Maybe it's the fact that I stay in my flesh,

Bringing shame when out of the same mouth I bless and curse your name,

Blind to the fact that every time I do what I will, I reject you,

Maybe it's the fact that I am not willing to go through the fire to become pure gold;

There are no shortcuts in the kingdom of God.

Ahh, breathing, I've been waiting for you,

But in reality you've been waiting for me.

Settle

I'm not your dime, jump-off, breezy, shorty, one thang, or wifey.
Sorry, I don't have a ring; I'm not your slut, tramp, or hood rat, but
so much more.
I don't wear a collar, bark, or walk on four hind legs, so watch what you say.
Your game I know all too well, your tender kisses and warm embraces.
As you gently touch my face,
I know it's just a set-up to get me intertwined in an unwanted soul tie.
I won't be mistreated or misused. I won't be dissed and dismissed,
Nine months later left high and dry, teary eyed with a little guy.
How do I know you're saying nothing but lies?
When I say, "Let's wait," you're begging me to stay.
Try'na leave, but your hand is on my thigh.
Looking at me like I must have made a mistake.
Nah, sorry, you heard right:
You won't waste my time or life over one night,
Plus I heard you kind of foul and got a child,
Quite a few, you ain't seen in a while.
But you say you're serious? Yeah, okay,
Clearly you're delirious.
Ignore the things that make it clear you're not the one for me? I'd be a fool.
I know my worth and value. I deserve better.
I'm the child of a king, and I want everything he has for me,
So I don't mind waiting and praying.
It's really not as bad as it seems. I won't fall for your schemes.
Not stuck-up, cocky, boogie, or mean, but confident:
I trust what my father said to me.

I'm precious, valuable above all rubies,

And really, you're not on my level.

Why would I lower my standards when I know I can do better?

Sorry, I'll never settle.

I Wonder

I wonder if they know I'm saved, I wonder if they know Jesus saves?
Because I've been examining everything I do, and lately I haven't been found true.
When someone says something I don't like, I'm cursing them out with all my might,
And I want to fight, yet if they do something wrong, I'm the first saying, "You ain't right."
While in church I holler, "Halleluiah, thank you, Jesus!" But when I get home
I scream "Get out my way, face, and space!"
And as my light dims, little by little I gossip, lie, cheat, and steal.
Jesus, I really need you to take the wheel!
I smile in people's faces, and as soon as they turn their backs,
My lips curl with so much hate.
Then in the same breathe I pray for people and say, "Lord, have your way,"
Not understanding why the power God has given isn't being manifested.
And no one I know is growing, but I claim to be "specially" anointed,
Forgetting your purpose and my mission instead of becoming better.
Got caught up in others' beliefs of how to be.
I guess I truly don't know what Christ-like means.
I smoke and drink and stay in the club too.
Yes, we all fall short, but is that really an excuse?
If someone walked up to me, would they think I'm just the enemy?
A wolf in sheep's clothing, a mere unperfected picture of what not to be,
Just claiming to have victory

It seems as if in proclaiming his name, I'm mainly just staining the name. Thankfully I still have time,
Because if I stood in front of the father now, he'd probably say,
"Depart from me."

Love

Searched for love in all the wrong places, wanting something one of a kind.
Searched low and high, searched far and wide,
Then there you were, as if you were patiently waiting the whole time,
As if we knew each other in a past life and the search was over.
You looked at me, and I felt your love holding me,
Your heart connecting with mine, touching the very essence of my soul.
Something about you sparks a light in me.
You see past those faults and those feelings I might try and hide.
I smile each time I get a glimpse of your eyes.
I'm on a natural high each time you come by.
I feel so vulnerable yet safe with you.
There's nothing I couldn't say, which is why I love you.
If this isn't love, then nothing I know is true.
I never have to question your faithfulness.
You always hold true.
Not one promise you have given me has been broken.
You know my worth and value and appreciate me,
Motivating me to be the best I can be.
Just your touch soothes me.
I'm captivated by your very being.
Looking at you is like looking at a clear view of my destiny.
I look at you and realize how much God loves me because he chose
you for me.

Marvelous Light

Looking out my window, seeing nothing but clouds and rain, it
Feels like all my work is in vain. Trials come, and that may be,
But I'm sick of the stress! Tired of the test, ready for my testimony,
The blessing in the lesson. All I see is death, war, famine, and poverty,
People sick, dying from disease, Satan running wild,
Persuading people to do all sorts of evil things!
This world is getting crazy, yeah, it's quite scary.
Feel like I'm not living or existing, all I really want to do is scream!
I know you have better, but these issues bother me.
Don't have the means to buy anything,
Not even a sweater to shield me from life's cold weather.
Since that day I decided to join your winning team,
The more the enemy fights me, yeah, it's serious.
I got demons continually coming while the devil sits back tormenting me.
Feeling my heart beating faster and faster, my life's a train wreck!
Nothing but a disaster! I can't even sleep, so I just weep. I
Need to pray, but the words and my voice can't seem to meet,
So I can't speak. I'm stuck, and it really sucks.
What do I have to do with this misery?
Reminded of this important thing: praise does confuse the enemy.
Then I heard a voice say, "Worship, pray, and sing.
I can bring you out be confident in this thing"
Once it was figured out, my mind cleared. I could concentrate
As the words finally began to formulate and resonate.
Tears began to flow; your words began to penetrate.
It was clear, and I could hear,

"Piercing everything unlike me inside you so you can grow,
Nothing will you lack, so don't slack."
Things will change in time, not yours but mine."
"So don't get weary; have faith. I suffered
And that cross I carried for you"
"Why? Because I love you; surely you can make it through."
I'm taking you out of the darkness
And bringing you into my marvelous light"

Compromising

I knew I wasn't the only one.
You say you love me; that's funny:
You told *her* that too.
See, I realized I never loved you,
Just entertained by an image,
Just the thought of you.
Nothing was there; I just wanted it to be. I
Hung on to every word you spoke,
But in my heart I knew nothing you said was true.
To you I will only be number two,
So we can't go on the way we have been.
I tried letting you fill that void in my heart that only God could heal.
Somehow you crept in for that steal.
You occupied all that space, and now I feel empty,
Fully vacant.
My investment was a waste.
But today is the day I stop settling for less,
'Cause all you do is leave me stressed. I
Feel like I'm suffocating in a room without air.
I can't put up with this mess,
So take care, have a good life, and God bless.
Misery loves company,
But I am not lonely and won't welcome it in.
It's time for us to depart and go our separate ways.
I've learned my lesson.
I will wait for the right one,

Jessica McDaniel

The one who will love me,

Hold me,

Who knows just the right words to say,

The one who will pray,

Stand by me,

Loves me for me, even the bad qualities,

Who understands the uniqueness of my beauty.

No more compromising

Or settling:

I've done enough of that.

So this time I'll wait and seek God's face.

I'll do exactly what he tells me,

No more compromising,

What Happened?

What happened to that girl?
The girl that everyone laughed at?
The one that they were so rude to
And constantly ridiculed too?
The one they tried to break?
The one they sent home crying every day?
What happened to the girl they teased, the one that had no
self-esteem?
The girl they talked about the second she turned her back?
Where is she?
The girl that had not a friend in the world,
Not a person that cared,
The girl that thought there would never be a better day,
That dreaded the thought of waking up?
That girl is dead,
No longer alive and well.
She is a new person
What happened is that she served that old girl an eviction notice.
She's now wiser, stronger, and tougher.
Since then she woke up and dried those tears she sank and swam in.
She told herself she would not let anyone try to talk down to her.
I am somebody, and no one will hold me.
This peace and joy they can't take.
No one but me can hurt or destroy this beautiful person I am.
No matter what anyone says or does,
Because I know who I am
And I know whose I am.
I'll always look up and never look down.

Long as I have you

Sinking, falling, and drowning in sin:
It's been hard since I've turned away from you once again.
I've ignored the things you've told me.
Now it's hard to sleep, hard to breathe.
How did I get in this place?
When will I get out?
God, are you there?
Just need to be in your presence again
Because it's been so long since I've been in that secret, sacred place.
Faith is failing and my spirit is weak.
Lord, please help free me!
These thoughts of doubt creep into my mind,
But I know it's just the enemy every time.
I know you haven't left or forsaken me.
Your word says so.
You're not a man that you should lie.
I know because it's been you carrying me.
You love me so much you died for me,
But I feel far away from you,
So I'm waiting and praying,
Searching for your will and way, discovering
Who and whose I am.
I know through you I can move mountains.
You do the impossible,
So Lord, breathe into me; make me whole.
Renew my mind and spirit.

The greater you are in me, the better I will be
In every circumstance of my life.
I know through you this battle is already won.
I will be victorious as long as I have you.

You Left

Cold hearted, selfish, and irresponsible,
No longer a man, but a child:
That's what I thought when you left,
As if I was meaningless, a sickness or disease
That a pregnancy infected you with.
And the only cure was for you to run away,
Leaving me behind
As if I was just a reflection in the rearview
Mirror of your mind.
You just drove by, not once looking back,
Gone in the blink of an eye,
Saddened, with no words to articulate that painful place.
My sadness soon turned to anger,
Anger to bitterness,
Bitterness to distress,
Distress to hate, and
Then from hate to a completely broken state.
Numb inside, emotionally unavailable,
My mind wasn't there.
See, when you left, you took something,
Something I'm trying so hard to get back, trust:
T-R-U-S-T.
And now every man I encounter reminds me of you.
Yeah, my mind was in a battle, in a violent war internally
You were trapped in that bitter part of my brain permanently.
Yeah, it was looking bad.

I was defeated constantly,

And all I could feel was rage.

How could you reject something you made?

A blessing the Lord gave?

It didn't matter, because my hurt, tears, and pain didn't bring no shame.

I promised I'd stop letting you damage me,

So I prayed, asked God to heal me.

Then I heard him whisper, "It's okay.

I have a plan. You may not understand, but all you have to do is hold my hand."

Then I knew everything would be all right

Because he's not like man.

I could trust him.

He's a real daddy

Reasoning

Was it your mother issues?
The horrific way they raised you?
The alcohol and drug abuse?
Is that your reason for acting the way you do?
What was I thinking staying with you?
One minute you loved and needed me, and
Then the next I was worthless.
Was it the father issues I had?
The low self-esteem?
The rejection and need for acceptance,
Trying to fill a void that only God could heal?
Was it stupidity?
Or a lack of identity?
Lack of understanding of who my father created me to be?
Oh yeah, that's right, it all started that one night that caused a soul tie:
That kiss and the sweet nothings you whispered.
Making me feel special,
All along you hid the real you,
Yet somehow I equated your fist to my face
As you ranted and raved
With "affection."
I grew up without direction,
Didn't know your real intentions,
Just sought after attention,
Not knowing what real love is,
Not understanding the greatest love:

The father dying on Calvary.
So I excused that unacceptable behavior:
"You're just going through some things.
You really do care; you adore me."
Yeah right!
Loved me so much?
My black right eye shows it.
You think of me so much; the bruises proves it.
You say you can't take your eyes off me,
That's why you act like I need a GPS device
To track me daily.
There was nothing you wouldn't do for me?
True,
Except stop punching me,
Sending me straight to the emergency
You can't live without me,
So you say if I leave, you will kill me.
But I dare you to try.
I'm not scared anymore,
But you should be.
Just try messing with me.
I was blinded and ignored the signs:
Something in your head just wasn't right,
But now I get it, and this is it.
You don't own me and won't control me.
No fear, no trick of the enemy will work.
The "I love you, I'm sorry, I need you" won't work.
"I'll never find anyone like you" just won't do.
You don't define me; you won't hold me!
It's over; we're through!

Holy Spirit

I'm in the fight for my life.

The enemy is after me,

Coming to steal, kill, and destroy,

Sneaky, conniving, and cunning as can be.

Watching, planning, and desiring to sift me as wheat,

Waiting and wanting to devour,

Trying to tear down the very things my father birthed in me

Every minute, second, and hour;

Even trying to steal my soul, joy, and peace,

Frustrating my purpose and plan,

But beaten, bruised, and at the point of no breath.

I still violently take back what the enemy has stolen from me.

I will rise. I will fight, prepared for war, clothed in the full armor.

I won't give up.

I will have nothing but victory.

My father paid the ultimate price for me.

So automatically I'm a winner.

The Holy Spirit resides in me.

Never Far

Looking in the mirror, seeing all my imperfections:
Malice, hate, anger, and everything else unseen.
Like not keeping my flesh under subjection,
Going opposite of the right direction,
Yet you whisper in my soul and spirit and say, "I love you anyway."
One arm of grace stretched toward me
While the other hand of mercy covers me.
Your holy spirit saturates my heart,
Purifying and ridding me of everything unclean.
Pushing me out of my comfort zone, launching me into my destiny,
Stirring up all the gifts you've poured into me,
Imagining all the possibilities of where I could be,
But because of your love
I'm safe and secure.
You make all things new for those
With a repentant, unhardened heart.
I come asking for forgiveness
As I let go of my past and embrace the future.
I know you're never far.

Ninety-Nine and a Half

I know ninety-nine and a half won't do, so I'm running, chasing after you.
I know ninety-nine and a half won't do, so I'm running, chasing after you.
But lately I've been feeling down, and I ain't talked to you in a while.
It's not that I'm too proud; it's just my faiths been kind of shaky,
And what I've been doing wouldn't make you smile.
Didn't mean to diss you; I was just following the crowd.
Didn't think of the consequences; there was no limit to the sins I committed.
I want to change, but I don't know how, and something tells me I can't.
I know I shouldn't listen, but the voice is so convincing.
But this race I gotta finish, 'cause ninety-nine and a half won't do,
So I'm chasing after you.
Yeah, I know my mission, but sometimes it seems impossible,
Because the more I pray, the more temptation comes my way.
I don't wanna give in. I don't wanna give up. I don't wanna choke!
Guess it's true what your servant Paul spoke:
When I wanna do good, evil's always right there.
Guess it's just a cross I gotta bare.
But I gotta prevail and fight the good fight, because as long as I got
you, I'll be all right.
'Cause ninety-nine and a half won't do, so I'm running, chasing after you.
Lord, it's not the end, so do a complete makeover.
I wanna be better; I wanna do better.
That why you left your sixty-six books of love letters.
I gotta make it so I can see your face.

I know time after time I put people and things in your place,

And made mistake after mistake.

But Lord, hear my humble cry.

I gotta get it right this time.

You came that I might have life, so I gotta live before I die.

Unashamed

People ask why your name I proclaim and constantly speak,
Why it's you I seek, and I just simply say, "I guess you could say I'm a Jesus freak."
Your name, none other, none greater; my sustainer, way maker, and protector;
Healer and guider; the ultimate purifier.
Only at your name do demons flee, and I'm able to get perfect peace.
You are the only shield against the wiles of the enemy,
The only one that can make me complete.
You are the King of kings, Lord of lords,
The great I AM, the Alpha and Omega,
Everything that I need you to be,
My strength when I am weak, the one no enemy can beat,
The one who saved me by grace and through my faith.
When I was lost, when I was a mess, when I was a wreck,
You changed my mind,
Dried the tears from my eyes.
When the enemy tried to capture me,
You grabbed me and held me close.
You kept me and paid my ransom, and now I'm free.
You kept my feet placed on solid ground.
You turned my ashes into beauty,
Breathed new life into me
When the enemy tried to torment me.
You spared me from the snares,
Turned my sadness to gladness,

Changed my mourning to joy and a song of worship
When I get out of line, you snatch me back.
I don't have to fear or be dismayed; you hold me in your hand.
My heart is filled with gratitude because you gave me a new walk,
A new talk, when I felt like I was suffocating.
You were my breaths of fresh air.
In my distress you gave me rest and called me blessed.
No one will understand my praise, and that's okay,
Because I know that every knee shall bow and every tongue will confess
Your name, so I'm unashamed.

Why I Don't Go to Church

"Oh, Jesus isn't real; he doesn't hear me, and the Bible contradicts itself a lot,

So I don't believe. That's why I don't go to church."

But when something goes wrong it's not Buddha or Muhammad's name I cry out or call on

Yet I turn around and say, "Please, Lord, bless me."

If a Christian does something that's not right and un-Christian-like,

I say, "I can't stand those church folks; that's exactly why I don't go to church."

Yet I turn around and ask them to pray for me later.

So who's truly the hypocrite?

Because the reality is why I don't go to church has everything to do with me.

I believe scientific evidence that tries to prove that Christ is a lie,

But I haven't read one word of the Bible to see that in fact

What it says actually is coming to pass.

All I have to do is look outside and see it's true.

But still I don't believe that Christ is alive,

Buying into the media and society's views on how to celebrate the birth and resurrection,

Subtracting Jesus from the equation, adding a Santa or a bunny,

Doing nothing to glorify him when actually I'm shunning him,

Because I'd rather believe in the fortune-teller's or magician's Horoscopes and exorcisms,

But I won't listen to one sentence of the word of God that the true prophet spoke.

I believe in heaven but don't understand that if there's a heaven, there's a hell,

And if I want to go to heaven, I have work to do.

And everything I do on earth counts too:

Buying into the lies of BET/MTV,

Thinking that I'm only good enough to be a drug dealer, rapper,

Singer, basketball player, or their wife when God has so much more than that for me.

I can get tattooed with "Only God can judge me," but do I really know God?

Do I really know that God will indeed judge me?

Not my family, friends, the church, or the pastor, but the *Master*.

When I'm being corrected, I'm offended because I'm really feeling convicted.

He was wounded for my transgressions bruised for *my* inequities,

But for some reason I think its lame to proclaim his name?

When it's only him that's breathing the very life into me,

Still I won't believe,

Wonder when I'll stop being deceived and

Believing Satan's lies and finally open my eyes to see:

Satan's the real reason why I don't go to church.

Unconditional

I see inside the depth of your soul.
I'm clearing out all the baggage,
The attitudes and different moods,
Replacing those tears running down your cheeks that you try to hide.
I know you feel like giving up and don't know how to trust.
You had goals and ambitions you didn't think you could reach
Because you had a childhood that was kind of dark,
And all your life you were told you weren't smart,
So you went shopping for validation instead of accepting my invitation.
You even went after love and got lust; now you're left crushed.
You turned away at the sound of my name as you
Ridiculed, blasphemed, slandered, and mocked
Because you needed someone to blame.
You don't want to feel my presence of glory.
You'd rather stay oppressed with life's worries.
So you treated me as a factious character in a make-believe story,
Refused to live by the words I spoke,
Left me feeling abandoned, choosing not to do what I commanded.
Still I gave grace,
Wiped your tears away, and still you ran astray
Instead of treating me like the Alpha and Omega.
In your eyes I'm nothing but a stranger.
I shed my blood for you in the womb. I knew you
And kept away all hurt and danger.
I know who you're turning out to be isn't a reflection of who you are
Or who I've called you to be.

All I want is your affection.

Just stay under my protection.

I'm trying to begin a good work.

I'm waiting with my arms outstretched.

I chose you,

Even after countless rejections I have unconditional love for you.

Unguarded

A lost, tortured soul full of insecurities,

Trapped by infirmities, uncertain of capabilities,

Unsound mind left with no rest,

No desire to know the truth,

Rejected because of the rejection,

No idea of who you truly are:

Yes! This is perfect!

You and all the others are blinded, and my job I can begin to complete.

After all, it's to steal, kill, and destroy,

Using that opening when they're feeling worthless.

See, they don't know their purpose.

And if I'm going to be thrown in that scorching hot lake of fire,

I'm taking them and their crowns with me,

Breaking up happy homes, destroying families,

Distorting people's true identities.

People perish for their lack of knowledge, and they want no wisdom.

Their hearts are heavy, and they don't know whose yoke is easy and whose burden is light,

Got them believing they can't win even though the can be victorious and more than conquerors.

They're not clothed in the full armor, so they can't fight the good fight.

See, I'm only around for a short while, and I'm going to come in like a flood,

Because they don't believe you will raise a standard and everything will be all right.

After all, their light has been diming daily, and it's not too bright.

They're not watching and praying; their unguarded making them the perfect target.

I Surrender

The love you have for me, there is none other that is greater,
Unfailing, ever-present, the same as yesterday and today.
People change, things change, but I'm glad your love remains the same.
Thankfully you're not like man; you never give up on me, despite my flaws.
You can see me at my worst but still remember what I am in you.
You threw away all my wrongs in the endless sea of forgetfulness,
Made me brand new, reshaped me like only a potter could,
Took my broken pieces, mended them back together, and healed me.
The love you have for me is overwhelming.
Who am I that you are mindful of me?
It amazes me that as I reject you, you do nothing but love me more and more.
You hold me at your right hand, and because of your love, I'm able to stand.
You have begun a good work, and I know you will bring it to a full completion.
I surrender.

I Want to Be Free

I want to be free completely,

Loosed from the pain that resides in my heart,

That screams out loud in the dark while I'm alone, deep in my thoughts.

I want to be loosed from the wounds that unforgiveness left me with,

Clean from all the scars and marks left on my heart.

I want the strains of brokenness, anger, resentment, contempt, and shame to go away.

I don't want to be bitter; I want to be better.

I don't want to hate or feel rage

When visions and memories of the things that took place in my life crowd my mind.

I don't want my soul bleeding.

I want it overflowing.

I want a fresh start.

I want to live in victory.

I want to be clean from the filthy rags of captivity sin has dressed me in.

I want to give you my problems and not pick them back up again.

I want to feel you near when I feel numb inside and tears continuously fill my eyes.

I want to look up to the sky and be assured everything is going to be all right.

I want to live by faith not sight.

I want to truly trust, believe, depend, and fully rely on you.

I want to fully understand I'm the apple of your eye.

I want to stay encouraged and not depressed.

I don't want to live a life of regret but one of abundance.

Jessica McDaniel

I want to be free and unmoved by the things I see.

I want to go by what you say to me and who you say I am

Not what others think of me.

I want to be free. I've looked for freedom in everything else,

Even tried shopping for it, as if it was a special remedy on a shelf, But

I just couldn't buy, But

now I know I need you, so I seek your face.

I want to know you. I want to know what true love is.

I want to love you the way you love me. I want to be pure, holy, and

found true.

I can only find it in you. In you there's liberty, stability, and intimacy.

So Lord, speak to me.

I don't want to know what eternity is without you and your spirit.

So Lord, use me; I want to be free, free in you.

This Walk Isn't for the Faint of Heart

As Christians our lives are always under a microscope,
Captured as if we're on the big movie screen for everyone to see.
They want to know if the church is just a supporting cast,
Only full of actors trying to win best performance of the year,
Wondering, are we really sincere?
We're not allowed to hurt, scream, get tired, get stressed, get depressed,
or bleed.
One wrong move and wrong turn and this Christian walk were
walking, People think we're doing nothing but talking.
And we're not really serious about living holy, righteous, pure, and
clean lives.
They don't know the things that we're tempted with or come up against.
Daily the enemy comes to steal, kill, and destroy, and it's a real fight
to gain peace.
Yes, it can leave you fatigued.
This walk isn't for the faint of heart,
Especially if you're really doing your part.
See, when disrespected, lied to, used, or abused,
We have to relax and chill to stay in his will.
Trust that it's not an easy thing to do.
Living by faith and not sight is hard,
Reading your Bible continuously, believing God
While looking inside of the freezer as it's completely empty and
collecting rust,
As you literally feel your heart sinking,
Yet trusting and still speaking not what you see or feel,

But what the word of the Lord says.

Trying not to question but wondering why is this happening,

Thinking to yourself, *Did I not fast, read, or pray enough?*

This walk gets tough; he never said it would be easy.

And when you're tired, ready to cry,

Someone calls your phone to say, "Can you pray for me?"

You stop what you're doing and begin to say, "Lord, have your way."

Not to mention the assumptions and accusations,

Even persecutions under false pretenses.

No, this walk truly isn't for the faint of heart.

See, you're tempted more than any other to do what you don't want to do,

So you have to continuously pray that you don't fall from grace,

And one mess-up or small mistake and the critics are amused,

Laughing, saying, "I told you they would fail."

You're given label after label,

And although no one but God has the right to judge you or put you in heaven or hell,

You're deemed nothing but a hypocrite. What people think you're selling, no one is buying.

You tell the truth, but they think you're lying.

You might backslide when you forget to stay prayed up.

The spirit is willing, but the flesh is weak.

They don't care or see the scars or tears or

How far God has brought you.

The great things in the community you've done,

And those lives you helped change or impact or encourage to get saved

See only what God is yet working on you with.

People illuminate every past mistake you make.

Yes, as a Christian there's a test daily, and it's your faith

If you're truly trying to live a righteous life.

I'm talking about not a part-time, maybe only on Sunday Christian,

But someone that knows the mission and goes out and witnesses

And truly worries about kingdom business, someone that brings
conviction.

Those who pray and intercede, their knees are weak from kneeling so
much.

You're changing, growing, and repenting daily,

But you're still faced with all types of scrutiny,

Called "holier than thou," "super saved," or "a holy roller"

When you act like none of those things.

When you tell someone about the great I AM,

They look at you with a blank stare and say, "I don't care."

Turn up! Turn down, for what?

They're not really interested in being heaven bound

Or the importance of getting to know him before you are buried in
the ground.

This Christian walk isn't for the faint of heart.

It's worth it, but it also comes with a cost.

You have to deny yourself and remember the one who went to the cross.

About the Poems

Eviction

The scripture in John 10:10 says that "the thief does not come except to steal, and to kill and to destroy. I have come that they may have life and have it more abundantly." The enemy truly tries to do just that! Steal, kill, and destroy. He's been trying to steal our identity, education, self-worth, values, and our faith, but will we let him? He wants to kill our mind, body, and spirit using the different cares and issues of the world. Haven't we had enough of his mind games and torture? Jesus is the truth, way, and life. Through him, his word, and increasing our faith, we have the victory. If we believe in Jesus, we must take him at his word, his whole word.

That includes the fact that there is a true enemy after us. Sometimes I don't think we as Christians truly understand that. We can easily get mad at people because of a grudge we have against them, even wanting to fight and get angry. But when are we going to get angry with the enemy? There are evil rulers and authorities of the unseen world that were fighting against us. Evil powers in this dark world, and evil spirits in the heavenly places as well. We must be strong in the Lord to stand as Ephesians 6:10–12 instructs us to. God has given us authority to overcome and have victory over the enemy's tricks, schemes, and traps. The enemy walks around seeking whom he can devour (1 Peter 5:8), but if we resist him he will flee (James 4:7).

We must wake up and put on the full armor of God. We must first understand the way the enemy operates. There is a mighty power of God working through those who believe in him and who are called according to his purpose to fight against him.

We are truly in a war, and the battle is not ours, but the Lord's. But we need some soldiers that will stand and declare his word. It's like going into combat, and you have weapons but won't use them or don't know how to use them to fight. It's useless! That's why God left his word, the B.I.B.L.E (book of instruction before leaving earth). We can win, but we must fight and keep our eyes open. Let's truly live in victory as our Father wanted us to; let's give the enemy an eviction!

It's Just Too Late

So many times we can believe we have forever to get into right standing with the Lord, but since we don't know the day or the hour, we must be prepared (Mathew24:13).We don't have to live in hell and die and go to hell. The world shall pass away, but the word of God is everlasting! Only what we do for Christ shall last. God says, "I stand at the door and knock if anyone hears my voice I will come into them" (Revelation 3:20).

God also says come to him who are weary and burned and he'll give rest; his yoke is easy and burden light! It's so easy to be on our own agenda, but the Lord wants us to be about his business. There are so many stereotypes about the church that can keep us from receiving our blessings and joining a body of believers. But the church has always been a place that can help and encourage us on our journey, regardless. We can be healed and delivered through the blood of Jesus.

We don't have to wait till it's too late. Life is so uncertain, and it's important to know when your life is over where you're going. If you passed away today, do you know where you would spend eternity? We all have to give an account of our lives and will be judged according to that (2 Corinthians 5:10). Don't let it be too late! There are no wrongs God can't make right, and no matter how far you have strayed or the paths you've taken, God can restore and heal you.

About Settling

Mathew 7:6 says, "Don't give what is holy to the dogs; nor cast your pearls before swine, lest they trample them under their feet, and turn and tear you into pieces." Yet sometimes we women settle for anything or anyone, doing just what the scripture says not to do. Out of loneliness we can get into a place of desperation. While in that desperation we can rush into something not of God.

The Bible talks about not awakening love until it's time (Song of Solomon 3:5). The saying that if you go to bed with dogs you'll wake up with fleas is so true! By settling we're not truly honoring God or ourselves. We're not giving God our best or getting the best we deserve. We accept the "hey sexy," "aye, girl" and "you are so fine" and give men a pass. We want approval, love, and acceptance so badly that we think that's the proper way to allow men to approach us. We can sadly even accept the fact that they don't respect God. We can give our hearts to the wrong one if we're not careful, looking past the warning signs of a damaging relationship. For example, our love interest may have baby after baby they refuse to take care of, have a woman or wife, and all in the name of lust we allow and accept it. Just because we hear "you so sexy, so fine" and "I love you" doesn't mean their intentions are pure and true

We are so precious to God and should always carry a standard as women of God; you don't have to accept or get less than the very best. After all, we are worth it! There is someone God has made and uniquely designed for each of us, but if we're wasting our time with someone not even worthy to look our way, we can miss meeting the right person. Never settle, and don't miss a true blessing by accepting a mess.

About 9-11 Emergency

In life we're going to have some trials and tribulations; that's a given. But sometimes we can cause our own problems because of the things we decide to do and not to do.

Disobedience, not submitting, and unconfessed sins can cause a lot of troubles in our life. Sometimes we require so much of God and ask and ask and ask him for something, but we give nothing in return. We sometimes don't want to go to church to give him praise or walk in his ways, but we expect him to bless us tremendously. Once we don't see anything manifesting, we wonder why.

His word says if you love him you will obey him, so obedience is better than sacrifice. So we should do a self-examination and make sure we're pleasing God. If much is to be given, much is required. Just like we expect God to do something for us, let's make sure we're making him proud.

About I Wonder

So many Christians fail to hold the standard. They do things out of the will of God and contradictory to the word of God. Some even like to judge and ridicule others just because they might sin in different ways. It's important not to judge, because if we're too busy judging, we're not loving.

If we're not praying and interceding, then we're failing the mission of God. We can't be messy Christians; we're called to be separate and to be a light and a vessel to the greatness of God. We should always keep the bar high and do our best, because God says not everyone that says *Lord* will enter. We must be careful how we conduct ourselves.

Imagine if we as believers got on one accord for the mission God laid out for us. Walking in authority, obedience, and submission, we would be very powerful. We could truly give the enemy a black eye.

About Marvelous Light

It's not easy being a Christian, but God left his Holy Spirit to help aid us. The Bible says in John 14:16, "And I will pray the Father, and He will give you another Helper, that He may abide with you forever."

God never said that we wouldn't suffer, going through persecutions and different tests. God did send the counselor to help us in those times. Again, it's so important to pray and stay strong in the Lord by putting on the full armor. In our darkest hours God is able to shine his light.

It's not easy to trust him, but it's a commandment, and it always pays off. God has such an amazing plan for our lives; it's up to us to tap into his marvelous light to find the way.

About Compromising

Too many times we allow our standards to fall below the norms, all in the name of lust. Confusing love and lust often happens. When we confuse lust with love, we allow people to take and take; we give our best and yet get nothing in return. We can give our bodies, hearts, and souls to someone that is so undeserving. We might even think that they're our soul mates when the truth of the matter is they probably don't even care about our souls. So how can they be our soul mates? We need to make sure God is the head of our lives. Only he knows whose best for us. The person may not be perfect but may be just what we need, but if we settle for less, we're left with scraps.

As Long as I Have You

You may be feeling alone, but God is a very present help! All you have to do is get into his word and learn his ways and submit. As long as we have the creator of everything, the beginning and the end, we can make it. No matter what we've gone through or deal with on a daily basis, we can win. It takes a lot to trust and have faith, but God said he'll never leave or forsake us.

About the Holy Spirit

The Holy Spirit is so awesome! It's God revealed in three distinct persons: the father, son, and the Holy Spirit, which is called the trinity. It guides us, speaks to us, and sanctifies us. It is the promised helper, and it gives us power. John 14:26 says, "But the Helper, the Holy Spirit, whom the Father will send in My name, He will teach you all things, and bring to your remembrance all things that I said to you." In 1 Thessalonians

1:4 it says, "For our gospel did not come to you in word only, but also in power, and in the Holy Spirit and in much assurance, as you know what kind of men we were among you for your sake."

We cannot do anything without the Holy Spirit's power. We cannot go wrong operating by the spirit and allowing it to fill and empower us. Feeling lost or confused? The Holy Spirit, if you allow him to, will work that out and renew you.

About Reasoning

Domestic abuse is very serious; it's become an epidemic. It's starting to occur at very early ages as well. We need to set a better standard for our daughters and sons. It's important to teach them the true meaning of love. We also need to get to the root of why our beautiful daughters and young women are allowing someone to physically or mentally abuse them.

We must understand children learn by what they see, not only what they are told. Nine times out of ten if a child has grown up watching someone being beaten, they are going to think, somewhere in the back of their mind, it's okay or acceptable. Especially if it occurs on an everyday basis, they will sometimes think that it's normal because that's all they see. No one deserves to be beaten, hurt, and abused; God loves us so much and paid a price for us. We are so valuable to him, and he loves us so much. Once we understand who we are in him and his great unfailing love for us, we won't tolerate disrespect from anyone.

Since God has paid a price for us, we don't have to live a life in hell and die and go to hell. Isaiah 53:4–5 says, "Surely He has borne our griefs and carried our sorrows; yet w esteemed Him stricken, Smitten by God, and afflicted." But he was wounded for our transgressions, and he was bruised for our iniquities; the chastisement for our peace was upon him, and by his stripes we are healed. We can be free from the pain and abuse, but it's a choice. God gives us free will and leaves it up to us. Choose him today! Choose life, not death.

About the Unconditional

There is nothing we can do to make Jesus stop loving us; he created us, called us, and truly loves us more than anything. That's the reason he sent his son: to show us the way and keep us from failing. It blows my mind when I think of his agape love for me and us. To love me in spite of all my wrongs, and I'm so unworthy: praise God! We mess up constantly, and yet he gives us another chance to get it right. We're the apple of his eye and his pride and joy. His love is the same as it was yesterday and today; it is unfailing, never changing, and most of all, unconditional. I even think of how people will stop loving you in a heartbeat over something so small, and yet the mighty God I serve says you're forgiven regardless! God deserves praise just for that!

About Surrender

Some people go their entire lives doing things their way and not God's way. They walk outside of the will of God and avoid God by all means. Ignoring all his instructions and commandments, ironically they wonder why their lives are crumbling daily.

There's no prayer, repentance, or reading going on in their daily lives. I have learned that the further you run and the more you disobey, the bigger the price you'll pay. Obedience is better than sacrifice (1 Samuel 15:22). God can do the cleaning and mending in our lives if we allow him to.

Hardship will come; he never said life is easy, but he left us the great counselor, the Holy Spirit, to help us get through. Surrendering to those who understand our ways doesn't work, and we need him to lead us. It's saying to God, "My life isn't my own, and whatever you want me to do, I'll do it. Surrender to him; you won't regret it!"

About Being Unashamed

Sometimes we can be embarrassed about being Christians or ministering; it's not an easy walk. But the important thing is to remember what the Lord has done for us. Dying and rising is enough for me to worship; let that be enough for you when you feel ashamed as well. We have an opportunity to share his love and the awesome things he's done in our lives.

Why not share it with someone else? We should always share the word of the Lord and be a help to the kingdom. Our life is not ours; it was won. It's about doing the work of the Lord. Someone has paid a price for it in other countries, and in America to be able to proclaim it without worrying about death is so important; we should be grateful for it. If we deny Jesus, he'll deny us.

About Why I Don't Go to Church

Some people disrespect God so much and allow negative influences to distract them from God. But when something goes wrong they are the first to call on him.

We can't let ungodly influences or circumstances change our views on our creator. He is still great no matter what we go through. He's always willing to heal us and is always watching over us. Let's not make excuses for doing what we want to do, what others do instead of taking responsibility for our own actions; when we stand in front of him, he won't want to hear about anyone but ourselves.

About Being Unguarded

Too many times we play into the enemy's schemes and tricks because we sometimes haven't been taught about the kingdom and godly principles or we stray away from them.

The Lord gives his instructions in his word on how to handle trials and tribulations. He gives us specific methods on how to handle the enemy; all we have to do is apply them. Since we sometimes don't apply it, whatever areas were struggling in the enemy will try to tears us down. We need to stay in the full armor and resist the enemy and he shall flee. But how many times have we fallen into his traps because we didn't resist him or the temptations he throws our way?

Imagine how happy he is that we have given into him and disobeyed our heavenly father. Imagine how hurt the father feels, the one who died for us and loves us unconditionally. Our daily provider. Sadly we sometimes do not realize it and don't care enough to want to repent. Let's not be unguarded.

Printed in the United States
By Bookmasters